This Journal Belongs To:

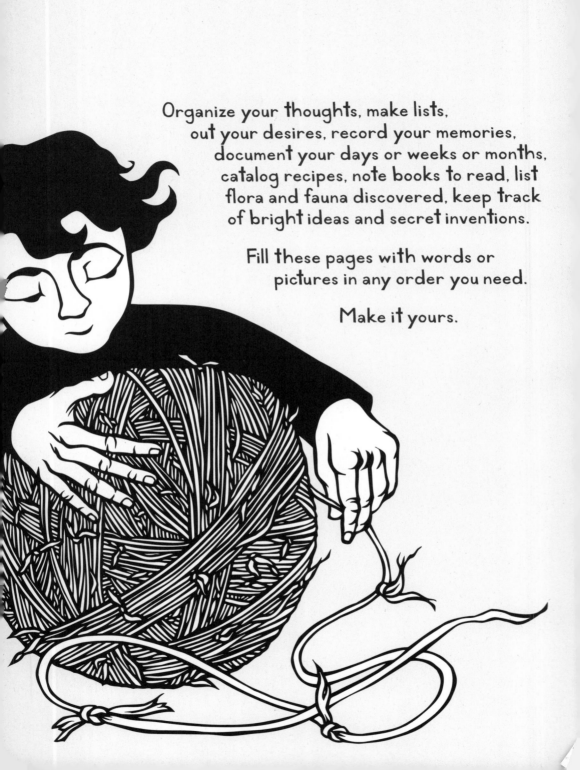

Organize your thoughts, make lists,
out your desires, record your memories,
document your days or weeks or months,
catalog recipes, note books to read, list
flora and fauna discovered, keep track
of bright ideas and secret inventions.

Fill these pages with words or
pictures in any order you need.

Make it yours.

Nikki McClure

THINGS TO MAKE AND DO
A Journal

SASQUATCH BOOKS
SEATTLE

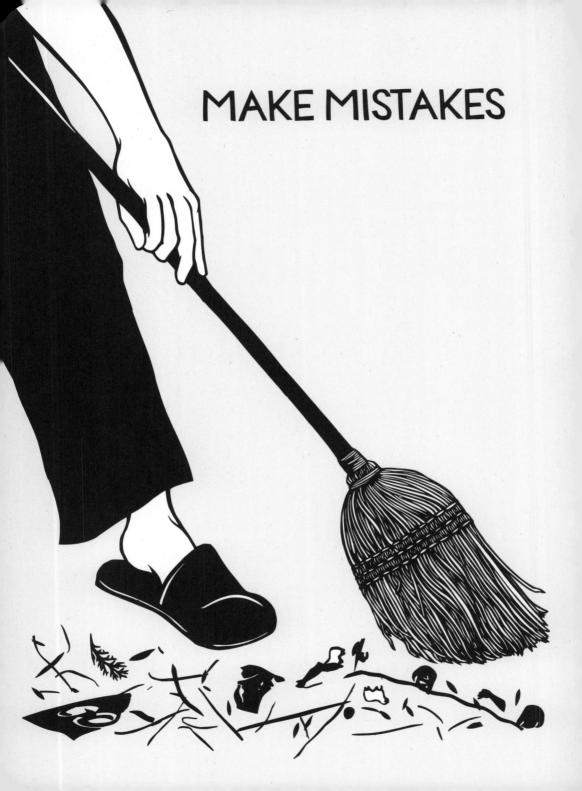

PLANS

GRAVITY

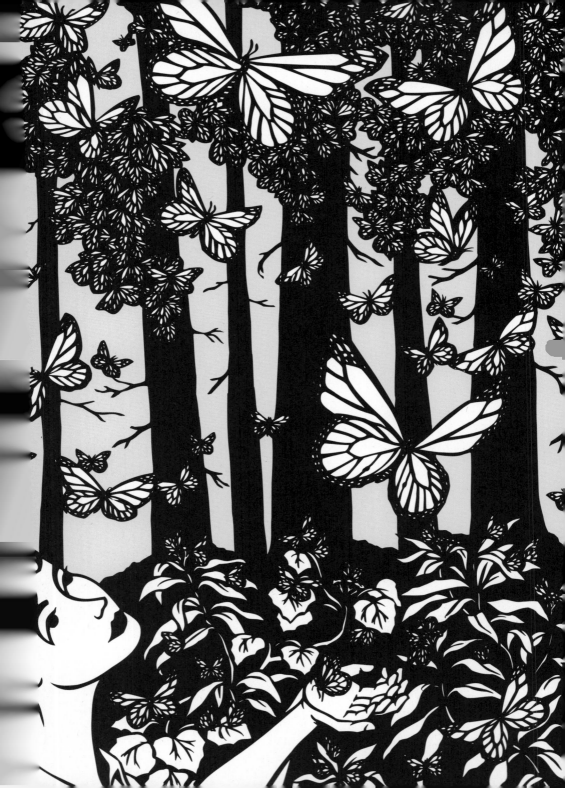

WISHES

WISHES

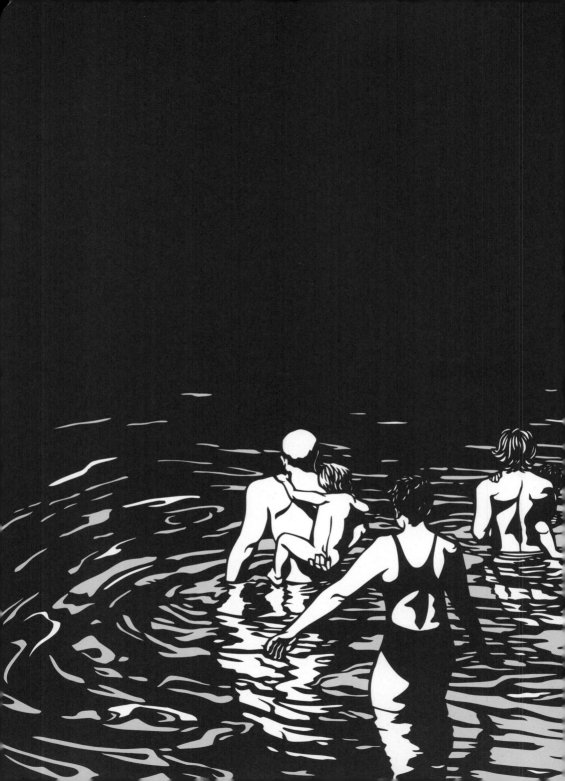

DREAMS

DREAMS

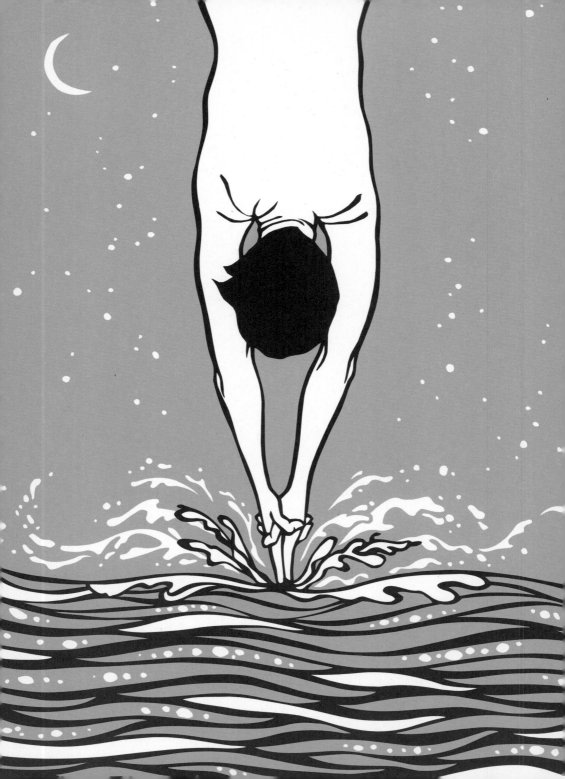

DREAMS

DREAMS

DREAMS

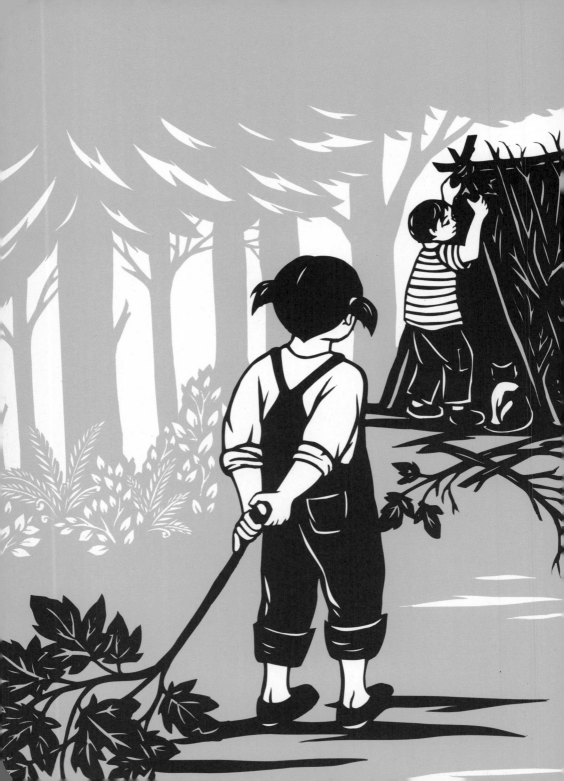

BUILD

BUILD

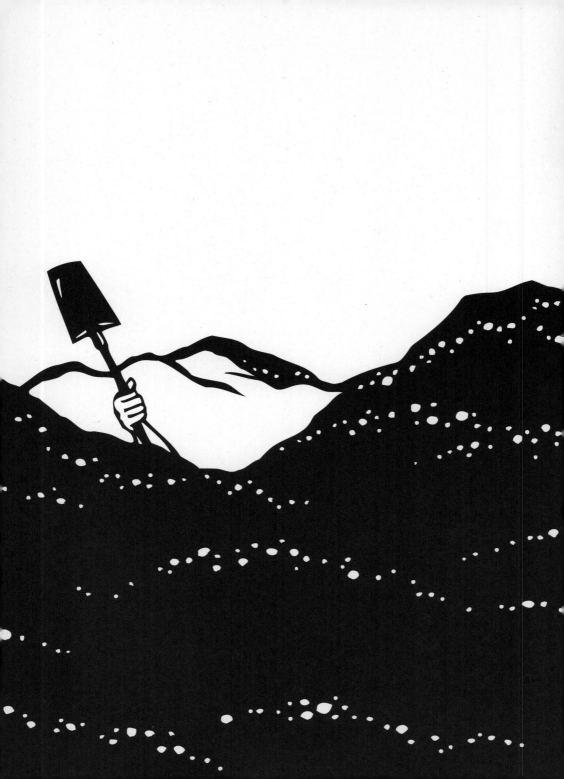

BUILD

BUILD

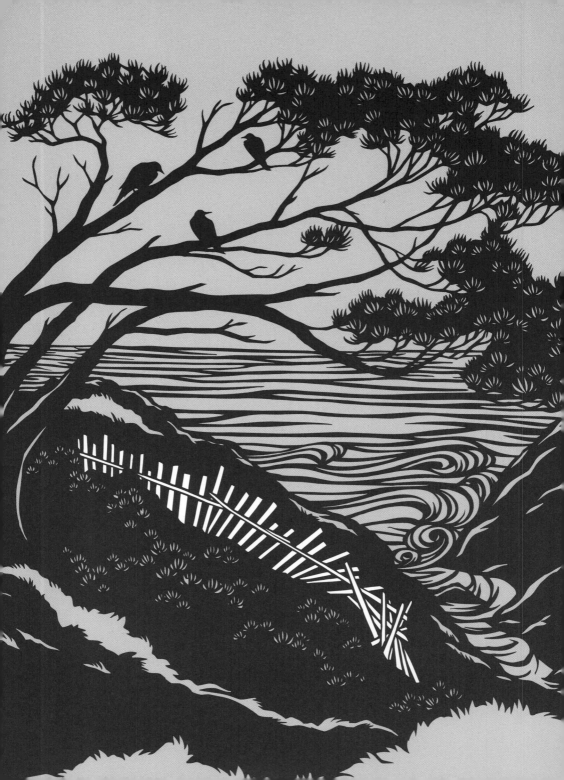

EXPLORE

EXPLORE

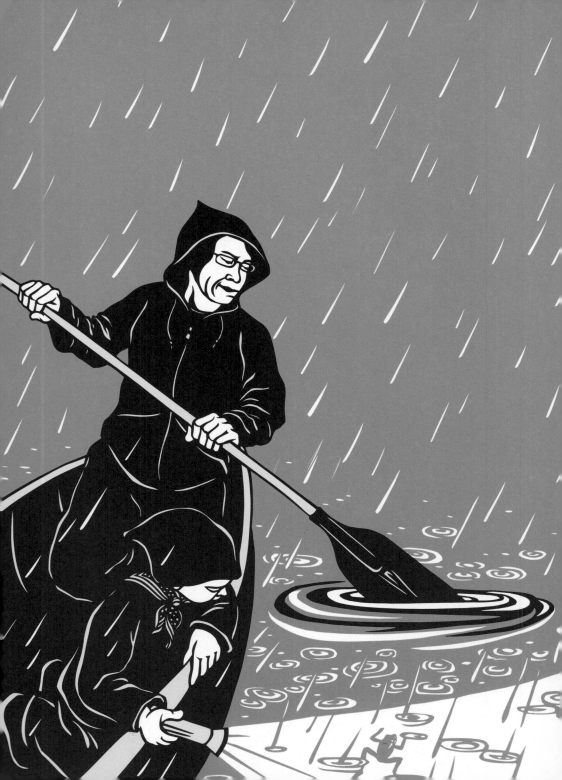

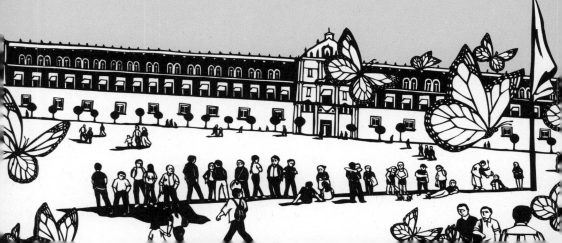

EXPLORE

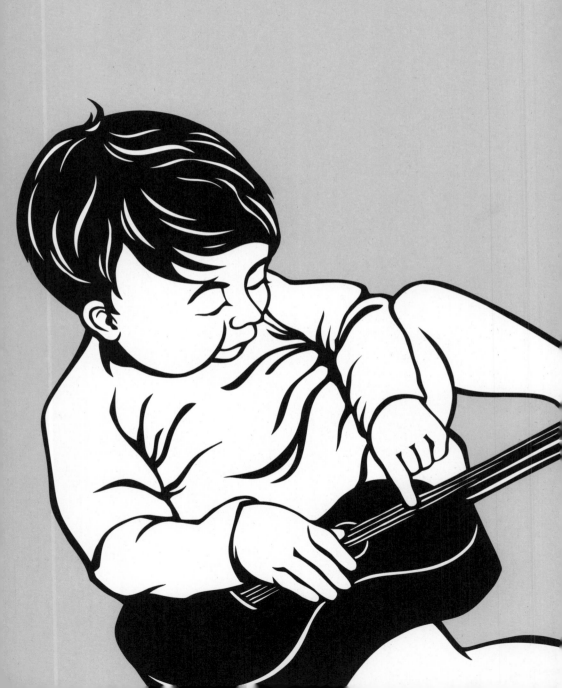

LEARN

LEARN

LEARN

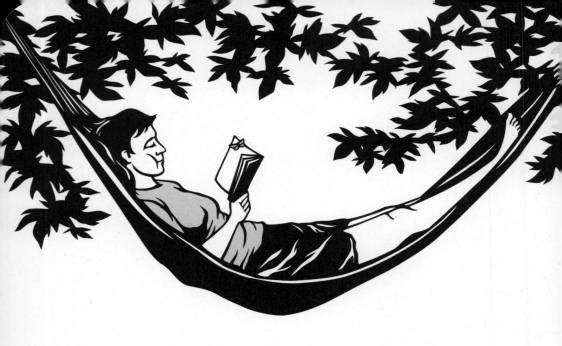

INCUBATE

LEARN

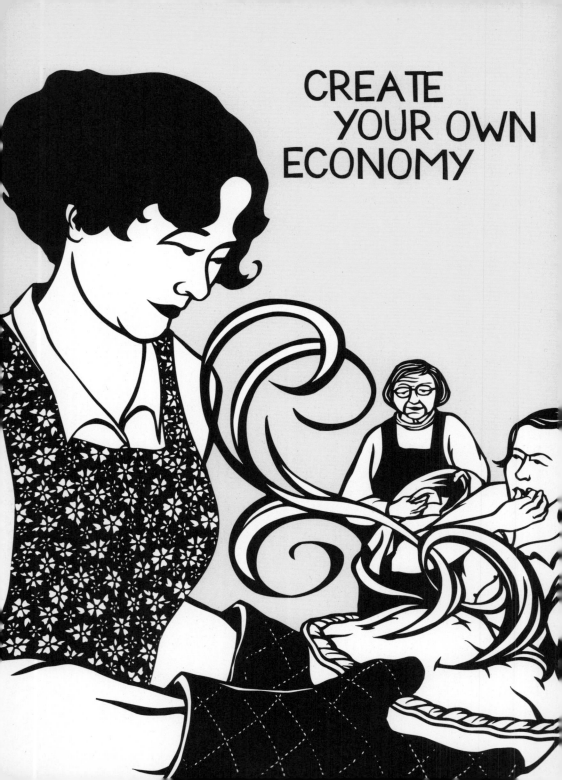

MAKE

MAKE

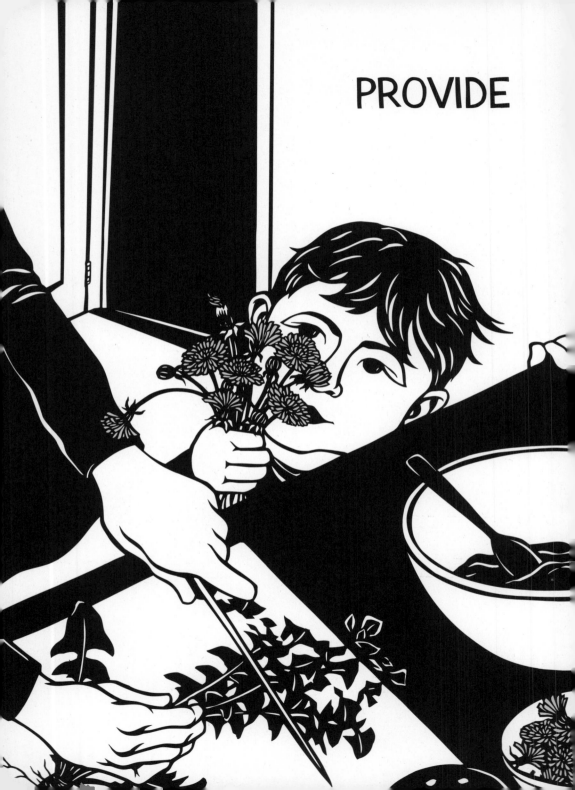

PROVIDE

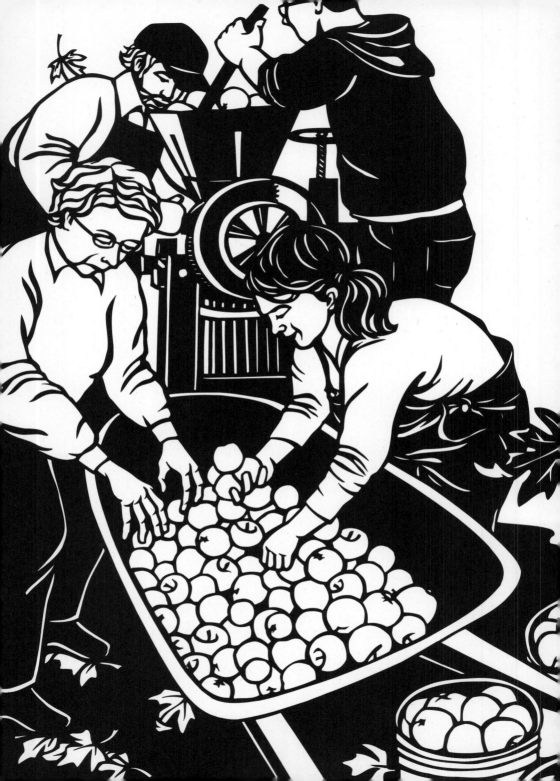

MAKE

MAKE

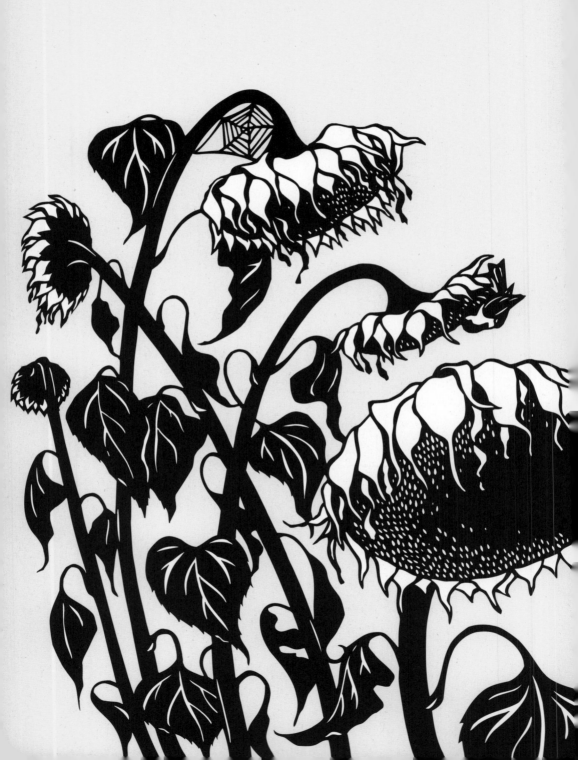

GROW

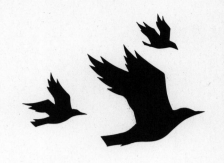

GROW

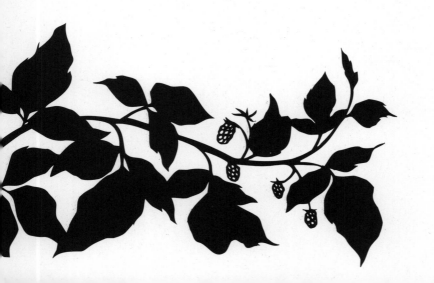

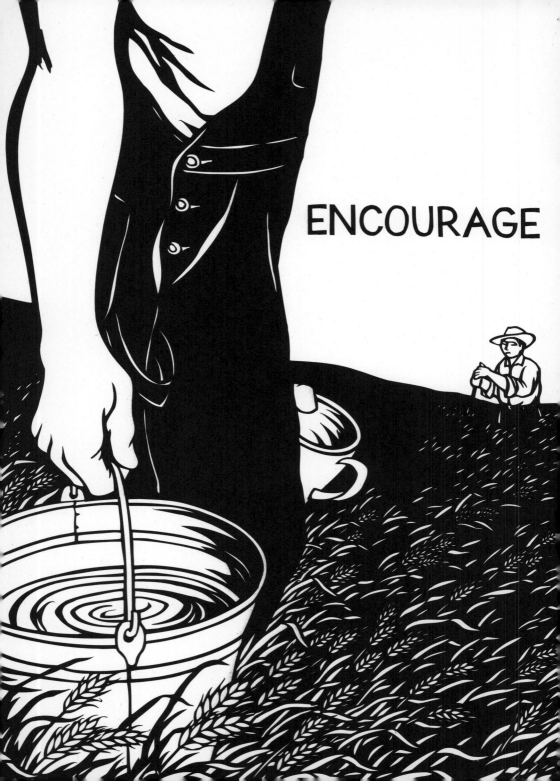

ENCOURAGE

GROW

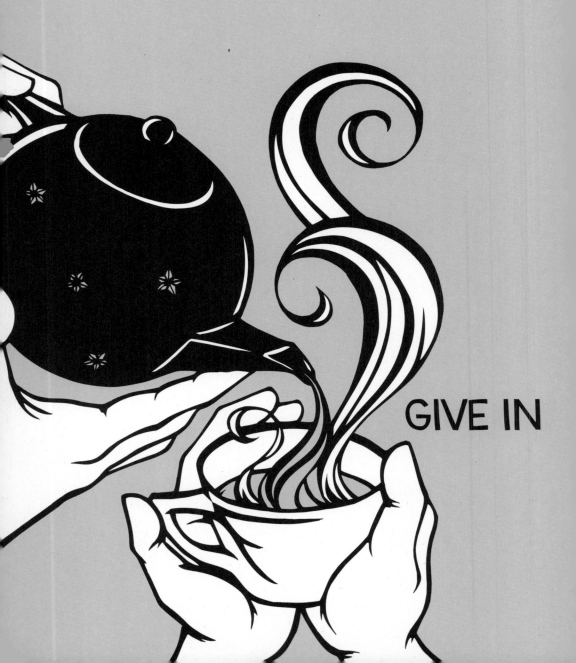

GIVE

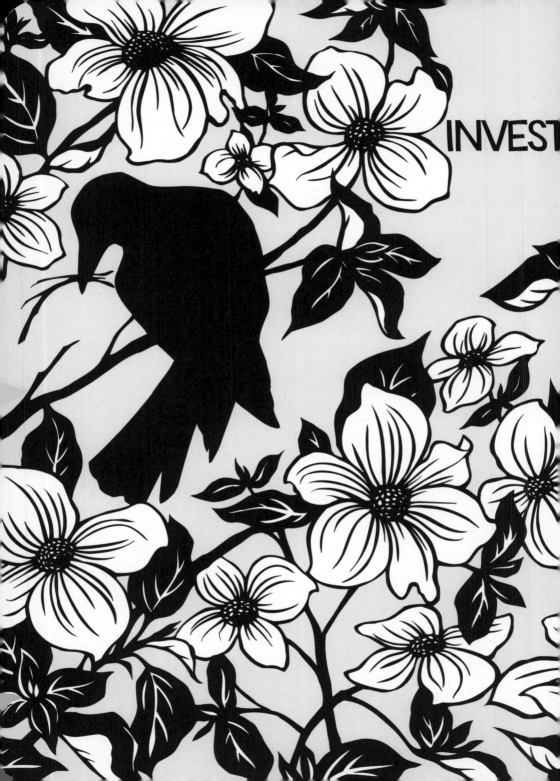

INVEST

GIVE

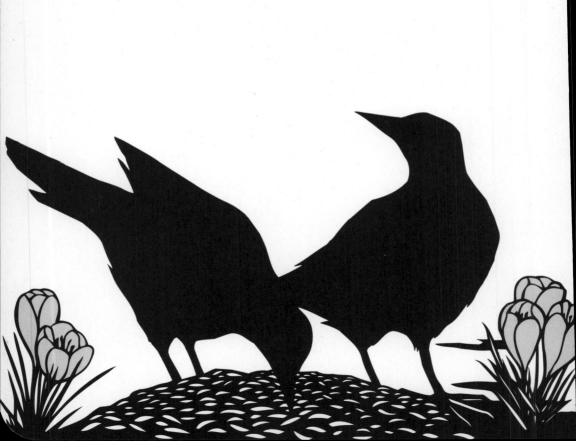

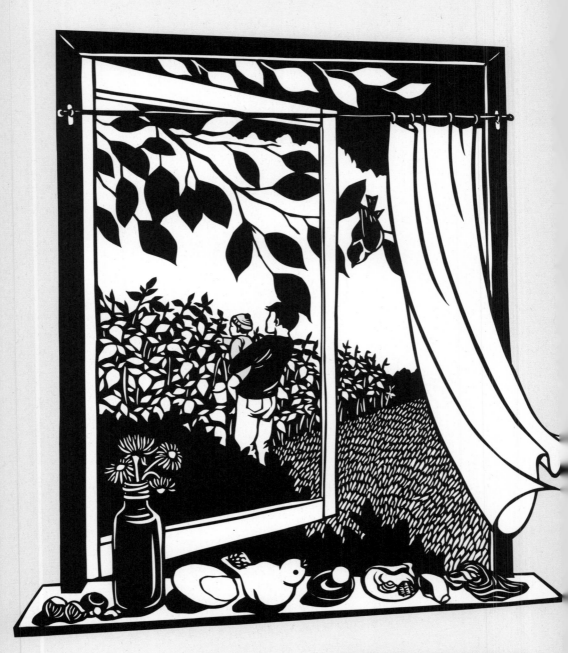

TREASURE

FIND

FIND

FIND

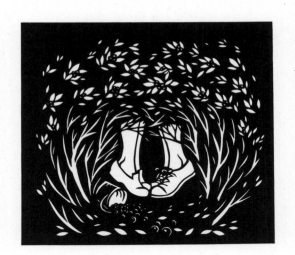

Using an X-acto knife, a single sheet of paper, and the inspiration that surrounds her at her Olympia, Washington, home, Nikki McClure lovingly creates her intricate and beautiful paper cuts. Her work constructs a bold graphic language that translates the complex poetry of family, nature, and activism into endearing, positive, and disarmingly powerful images. Nikki makes a calendar every year as well as many books and pies.

www.nikkimcclure.com

Printed in China
Printed on recycled paper
Published by Sasquatch Books
Distributed by PGW/Perseus
15 14 13 12 11 10 09 08 9 8 7 6 5 4 3 2 1

Book design: Kate Basart/Union Pageworks
ISBN-10: 1-57061-564-0 ISBN-13: 978-1-57061-564-1
SASQUATCH BOOKS
119 South Main Street, Suite 400 | Seattle, WA 98104 206.467.4300
www.sasquatchbooks.com | custserv@sasquatchbooks.com